Welcome to Colorist's Sp[...]

For those who love to color!
I am a coloring book illustrator & also adore to color! With nearly 30 decades of studying & creating art through college, university & professionally…here are my tips & secrets to making your coloring pages POP!

This book is bursting with:
Step by step guides to items commonly found in adult coloring books, background tricks, ideas, and practice pages!
Plus bonus color charts to record your colors and mediums.

Inside guides of this copy are in COLOR!
This book is also available with a grayscale interior.

Supportive material - website **www.helenclaireart.co.uk**

The paper in this book has a good tooth for pencils, soft & oil pastels, & for pens (place a blotting sheet underneath for stronger markers) and can even hold some paint, PVA glue and nail polish when applied over a pen/pencil base…
as you will discover!

This book is a delicious side dish to coloring books.

Check out my range of grown-up coloring books.
Inky Ocean, Inky Garden, Inky Mandalas, Inky Mandalas Mix, Inky Extreme, Inky Dinky Blossom, Inky Lifestyle, Inky Galaxy, Inky Whimsy and Inky Christmas, Inky Theatrical Faces.

Enjoy, experiment, have fun, get messy!

Content is copyright of Helen Elliston
– While I am happy for you to proudly show off online/on social media your shiny new gems & spotted mushrooms from this book… please respect my work by not posting photographs of the individual page guides in their entirety, without prior permission.

Copyright © 2017 Helen Elliston
All rights reserved.
ISBN: 15466465490
ISBN-13: 978-1546646594

INDEX

Shading & blending pencils
Light & shade on 3D spheres and boxes

HAIR, LIPS & SKIN
Realistic eyes… and teardrops! Eye highlights to suit the mood
Luscious red lips
Clear lens glasses & dark sunglasses
Skin tone & hair

NATURE
Water drops & air bubbles
Shiny butterfly
Red rose & daisy
Clouds
Glossy spotted mushroom
Soap bubbles & neon bubbles
Mermaid scales
Animal fur impressing technique
Translucent fairy wings

3D SHAPES & OBJECTS
3D red bows & clear wine glass
Balloons
Flowing dress fabric
Golden crown
Glowing candles & lanterns
Chrome it up!
Glass-look tear shapes + a scene to color.

GEMS
Purple & yellow circular cabochon
Oval cracked glass
Glossy red heart
Glinting crystals
Red ruby & Faceted pear cut effect
Gembugs & Glassy fish
Silver pearl & Polished amber gems
Black diamond
Galactic oval

BACKGROUNDS
Snowfall
Stained glass effect
Give flat coloring a boost
Red sunset over water
Soft pastel effects
Ocean water & Wax resist
Galactic star & Fairy dust trails
Woodgrain
Contemporary paint drips
Rubbings & pen dots
Adding shadows
Pretty moon & stars
Marker pen tricks.
Fireworks
Color wheel experiments & a scene to color.
Cut-out signature art cards
Color charts to chart your mediums!

SHADING GRADIENTS

The basics

Step 1
Using just one colour of pencil, in either coil-like or zigzag motions. Slide your wrist across the page as you go.

Use pressure, to gain saturated colour at the darkest part.

dark ⟶ light

- zigzag
- coil
- Light, feathering circles (scumbling)

Step 2
Gradually reduce the pressure to just a tickling of the page as your move across. It's okay to lift the pencil & go back over, building up in layers. Holding the pencil tip at an angle is helpful for shading as it reduces harsh marks & gives more even coverage.

Mastering shading gives you a basis to advance your skills, and bring your colouring to life, by introducing light and shade.

Practice!

Shade from dark to light and to dark again. ⟶

dark ⟶ light ⟶ dark

Try in a different colour. ⟶

Try scumbling...
(light, feathering circles) ⟶
This is a good technique to learn so that you can confidently shade different shapes & intricate areas.

BURNISHING

White pencil

Smooth out white flecks in the tooth of the paper by burnishing. This is applying pressure with usually a white pencil. It blends the pigment together and pushes it into the grain of the paper. Start on the light, move to the dark to minimise transferring darker pigment to lighter areas.

BLENDING ONE COLOURED PENCIL INTO ANOTHER

Aim to achieve no discernable seam, no faded area between, and neither colour appearing dominant.

Apply your 'shading' skills to help you blend.

Pressure scale — Hard ◀ ▶ Light

Hold tip at an angle to shade lighter

Press hard on pencil point to shade darker

1. Shade a red pencil from dark to light, just how you did when 'shading'

2. Introduce an orange pencil. Start at the point where the red starts to become less 'saturated'. Fade out the orange across the page, so that you have a stretch of pure orange that extends beyond the red.

3. Scumble over the join area. Shade the LIGHTER OVER THE DARKER colour to help create a seamless transition.

Use high pressure when blending the lighter over the darker

Use light, feathering circles to build up your colours, and blend them together. This action helps to reduce harsh, noticeable marks and gives more even coverage.

Practice scumbling (light, feathering circles)
Practice pressing hard and then reducing the pressure as you move across the paper.

Go back over your colours if you need to make them more saturated, or to create a smoother blend.

Colours close to each other in the colour wheel are easiest to blend together, because they are made of a shared hue.

Try these!

Red into orange...

Purple, red, orange then yellow.

Purple, blue, green then yellow.

Smooth out white flecks by burnishing (pressure shading) with a white pencil. Burnish on the lighter colours first to avoid muddying the colours.

3D SPHERES & BOXES

Create 3-dimensional objects by shading in gradients.

Light source

Highlight

Core shadow

Reflected light - makes all the difference! Light is reflecting off the smooth surface onto the base of the sphere.

Cast shadow

Use light, feathering circles (scumbling) to build up the gradients. This offers more even application & reduces the appearance of noticable strokes.

A cast shadow grounds your object on a surface, preventing it from looking like it is floating in space.

Darkest side

Shadow

Light source

Lightest side

reflected light.

(1 = palest. 5 = darkest)

Shadow falls on the opposite side of light.

very dark shadow here, where no light hits.

How to colour
LUSCIOUS HAIR, LIPS & SKIN TONE
Eyes, spectacles & sunglasses

HOW TO CREATE REALISTIC EYES

1 Light flesh pencil. Shade the majority of the area, leaving white areas as above.

2 Burnt ochre pencil (tan) Blend out into the flesh colour.

3 Venetian red pencil (a mid brown with a red tone as opposed to burnt ochre which is an orange tone) This layer balances the skin, so that it isn't too orange)

4 Dark brown pencil. As well as needed for shadow and depth, here I am also using this shade as eyeshadow. Blend and fade out into the lighter colours.

5 Black pencil. This goes over the areas of dark brown near the lashes and creases of the lid where they recede.

6 Light blue pencil for the iris. Leave the bottom of the iris slightly paler. It is okay to have some white gap lines in the blue.

REALISTIC EYES PART 2

7 Darker blue. As before, less colour at the bottom of the iris. Shade heavier around the border. Add lines/zigzags fanning around the eye for a more realistic finish.

8 Leave a white gap

Light pink. Add to the corners of the eye. Fade into the white of the eyeball. Leave a white gap as shown above.

9 Add some darker pink to the corners. Blend in a touch of yellow to the white gap of the inner corner.

10 Add grey pencil around the edges of the white eyeball & the top of the iris. Fade softly into the white.

11 Add black pencil over the eyeball and iris under the top lash line. This is shadow on the eyeball from the eyelid and lashes above it.

12 Using white gel pen, draw over the black guideline of the lower lid that touches the eyeball, just once, to reduce the strong black to a pale grey. (We don't want this line to be a strong bright white)

REALISTIC EYES PART 3

13 Use an ultra-fine (2-3 mm nib) coloured pencil eraser (Tombow Mono Zero) to remove 2 lines of colour, to create skin creases below the eye.

14 Add very subtle blue at the side of the nose/eye socket.

15 To add a tear drop... erase some skin colour (to make it paler) in a tear shape as above. Erase more at the bottom of the tear.

- Slightly lighten the lashes with smudged white gel pen if needed.
- Add dark brown shadow with a crisp edge that fades away.

16 Use white gel pen for bold highlights to the tear, the bottom of the eyeball, and the iris. Zigzag top half of the iris highlight is caused by the eyelashes.

- use 2 layers of white for stronger highlights.
- Gap in the centre.
- paler here

1 Burnt ochre (tan) — darker on this edge

2 Light flesh. Blend.

3 Dark brown. fade the shadow out and away.

4 Crisp black line on right edge of tear.

5 White gel pen highlights. White. Fade this white dot down into skin tone.

TEAR ON CHEEK

GLISTENING EYES

simple

dreamy

For soft feathered highlight areas, use white gel pen or paint, & blot to soften.

magical

eye highlights make all the difference!

cheeky

fantasy

moon reflection

LIPS

Create luscious lips!

white highlights

Layer 1
Bright red pencil.
Colour the area shown,
leaving white highlights as indicated
-central on bottom lip, high up on the upper lip.
When shading around the white highlights,
have some areas soft & some crisp.
Use directional up & down strokes in the middle,
& curved edge strokes as you move out to each
corner - to resemble lip creases and perspective.

((||))

Layer 2
Deep red pencil.
Press hard around the outskirts,
blend inwards with the red.
Leave a little line uncoloured
at the bottom. (reflected light)

Try it!

Layer 3
Dark Indigo pencil.
(black if you don't have this colour)
Build this layer up gradually,
blend using little feathered circles.
The indigo gives more depth and shadow.

Layer 4
Use a bright red fineliner pen. Apply in directional
strokes (see layer 1)
The pen gives a brighter and bolder finish.
For a warm glow...
add a hint of yellow pencil to the four end
corners of the white highlight areas.

For a glossy look, try a sweep of clear nail polish or PVA clue (dries clear). You could even add a light sprinkle of glitter!

CLEAR LENS GLASSES

Here are three ways to give the impression of glass on clear lens glasses, and therefore create a focal point.

Shade lenses in grey or brown coloured pencils in the areas and tones as shown.

Smooth out any 'grainy' look, by pressure shading in white pencil.

Then strengthen or add highlights using white gel pen.

Colours need to be transparent (allow the skin tone beneath to be perceptible) Shade with grey pencils (or browns for a sepia look)

Have fun with little reflected details... Can you spot the cat?!

Graduated shading of dark down to light, with a strong white highlight.

Bold white zigzag light reflection.

Wide and narrow streaks.

For transparent-looking white highlights, either erase some of your pencil, or apply white gel pen, and dab with a finger to lift off some of the colour.

Try clear or shimmer nail polish on top.

Dark central and side zones, with strong, curved white highlights.

Image from adult Colouring book: Inky Theatrical Faces.

SUNGLASSES
Three ways to achieve that super-polished look on dark sunglasses.

Use grey pencil to shade your shapes and gradients. Then black pen for the bold black areas. Then add white highlights in gel pen or craft paint.

Bold white highlights against the dark tones give a super shiny feel.

Use black pen for the most saturated black sections.

Suggest tall building reflections in gradients of grey and black pencil.

White highlights - suggestion of a window reflecting off the lens.

Whether it's a star, curve, stripe or circle... add a bold white highlight against the black - this gives a dramatic & polished appearance.

This highlight fades from light grey pencil up to white (the white paper)

Suggestion of a person in front of the subject in black pen.

Black pen

Allow the skin tone to be slightly perceptible through the grey here. For a 'tinted glasses' look, fade the solid black down into the transparent grey.

SKIN TONE
Part 1

My layer by layer guide to colouring pale skin tone on this face using pencils!

Using the colours indicated, shade the sections in order. Practice on the line drawings on the pages that follow.

Layer 1
Pale flesh pencil.
Colour all over as shown. Leave the white sections as uncoloured white paper - they are where areas of the face catch the light. Keep the border along the jaw line very light aswell - reflected light.

Layer 2
Covering less area this time, use burnt ochre pencil (tan).

Using small, light, feathering circles, build up your layer, and softly blend into the flesh base.
This is still a light (pale) layer, just slightly darker than your base, and is adding some definition and warmth.

SKIN TONE
Part 2

Layer 3
Using raw umber (a slightly darker brown) shade the areas indicated, blending into your previous colour.

Layer 4
Use a dark grey in these areas. This builds definition and shadow without adding more orange tones. Apply the grey lightly at first, you don't want it to come out too dark or like black. These areas are to be slightly darker than the previous layer.

If you are worried your face is looking too orange or brown... don't worry!
We will add touches of green and red later to balance it out.

Layer 5
This is your darkest layer - defining features by adding a bit more shadow. Add feathered touches of dark brown in the areas shown. Build slowly.
Don't press too hard too quickly. It is easier to add more as needed than to remove colour.

SKIN TONE
Part 3

Layer 6
If skin tone is bland and in need of a lift...
Using red pencil, softly add some red to the areas shown.
venetian red is a good pencil to begin with because it is less bold. If you need more rouge you can then switch to a brighter red. A normal red will be fine on it's own... just don't overdo it!

Layer 7
Too warm, brown or orange...?
Use an earthy green/yellowgreen pencil to cool things down.
Earthy green is a midtone pencil and dull compared to a bright leaf green. Shade gently where indicated to balance out the skin tone.

Layer 8
You may need to go back over some of the colours. You may wish to pressure shade over all colours with the pale flesh pencil, or white pencil, to burnish/blend/smooth out some areas. (shade the light areas first to avoid muddying your pale colours with the darker colours.)

If you have muddied your white highlights, dab and blot to lift off some colour using a kneadable art eraser, or even blobs of Blu-tac.

Keep practicing and you will get better at judging the colours and tones.

PRACTICE SKIN TONE

Record your colours and medium beneath the image, to refer back to.
This practice image is a cropped version of a page from Inky Theatrical Faces.

HAIR STRANDS
Brunette

Using sharpened pencils, build up layers from dark to light in colour.
Use a flicking motion to taper (softly thin out) the end of your stroke.

To give black hair a lift try including some blue.

In this example I used:
Black
Then dark brown & light brown.
Then red followed by yellow.

Strokes tapered into the highlight area.

Be sure to leave a white area
in the most protruding parts of hair locks
-to demonstrate the catching of light.
Go darker on the areas that fall back, and are in shadow.
the example below shows a photo of a page
I started from Inky Theatrical Faces...

Black layer

Add a ring of light around the forehead/temple

Dark brown then light brown layers.

Red then yellow layers.

Shadows caused by face & locks above

Extra details like white dots & tiny stars can give your finished piece a boost!

STRIKING BLUE HAIR
using pens!

Try different colour schemes.

1 — Light turquoise or blue marker pen. Shade all of the hair.

2 — Taper ends. Medium blue. Avoid protruding areas that will catch the light. Taper the ends of your marks (make the ends thinner). *Tapered end*

3 — Dark blue, in areas that fall back or are in shadow because they are beneath other locks.

4 — Use turqoise or blue, light to mid tone gel pen. Apply fine lines as hair strands, flowing with the direction of hair.

Add plenty of white to this area.

5 — Use white gel pen to add highlights to protruding areas.

6 — Add strokes of black fineliner pen over some of the dark blue for extra shadow/depth.

7 — For higher visual impact... add dots using white gel pen, & glints in white gel pen or neon yellow gel pen.

A finished example. (Coloured in pen, following this guide)

PRACTICE PAGE

Have a go!

How to colour
BEAUTIFUL & DELICATE NATURE

RUNNING WATERDROPS ON LEAVES

1
Shade your leaf in pencil, either leave a gap for a water drop, or erase some pencil...

Try it!

Light-source

leave a white gap that fades off.

Fade down

For round drops, take the light colour around the top edge.

curve

Shade the lighter over the darker, at each step, to help blend.

Fade away

2
Draw the outline on your leaf in mid green pencil. Waterdrops are transparent, so we will use greens to create a drop on a green leaf.

3
Use light green to shade the areas shown above. Fade your green down, getting lighter toward the bottom right edge.

4
Blend darker green in the areas shown. Blend in a subtle curve shape inside the drop.

shadow
shadow
white

Try other shapes!

make this dot whiter

white fades away

crisp edge

5
Blend black pencil to darken the inside of the drop, and at the bottom to strengthen the shadow. Give the bottom right of the drop a crisp black edge.

6
You may wish to smooth your colours by pressure shading with a white pencil. Next: Use white gel pen to add highlights. Make the dot in the shadow whiter than the length as it fades away.

AIR BUBBLES!
PART 1
in coloured pencil

Layer 1
Use a pale blue pencil to create a water background. Either leave circular spaces for drawing bubbles, or remove a circle of pencil with a circle of Blu-tac or kneadable art eraser. Press and lift, don't rub to erase. The circle doesn't need to be totally clean and crisp.

Practice large at first, then try smaller bubbles.

Layer 2
Outline the whole circle with a pale blue pencil. Use a medium blue pencil to make the outline darker on the top left and bottom right quarters.

Layer 3
Using pale blue, shade down the centre of the bubble, from dark to light, Bubbles are transparent, so be sure to leave plenty of white here.

Layer 4
Use a medium blue pencil to add darker shapes and marks. Blend the edges a little in to the pale blue.

AIR BUBBLES! Part 2
in coloured pencil

Layer 5
Enhance the inside of the marks made in layer 4 with your darkest blue pencil.

Layer 6
Using black pencil, add a few dots and dashes inside the bubble. Add a dark and slightly larger mark here, to create more contrast.

Try it

Layer 7
Use white craft paint and a fine brush to add highlights.

FOR SIMPLE BUBBLES....

Draw a circle in white gel pen. Shade blue, fading it down into the bubble.
Add white hightlights.

FOR TINY SPARKLY BUBBLES...

Draw a tiny circle in mid blue pencil. Fill with a blob of opaque, fine-glitter glue. Add a little dab of silver nail polish on top.

SHINY BUTTERFLY

Pressure shade in yellow pencil 3/4 of the way across.

Shade bright red pencil from the other end, fading out to meet the yellow about half way. BLEND the two colours by pressure shading over the top with the yellow pencil.

Add a little dark red pencil on the edge. Fade into the bright red.

Try not to muddy the white.

TOP WINGS
Using dark grey pencil, shade the border areas. Fade your colour down to white in the central areas. Pressure shade in white pencil to smooth out.

Make your butterfly look more 3D by adding darker grey above the black guideline on the top & left edge of your curves.

Grey — Purple

Colour bottom wings in the same way, but add purple in the area near to the body... blending purple out into grey. This gives a more aesthically pleasing finish.

Try it!

White curve

White dots & generous paint blobs

Add highlights using white craft paint & a fine brush, and/or some gel pen.

RED ROSE

Edges

Layer 1
Shade all the petals in bright red pencil, fading out toward the edges as shown here.

For a smoother finish to your rose, burnish by pressure shading in white pencil over the top.

Layer 2
Dark red pencil.
Colour less of the petal area this time, so that you don't cover over all of the bright red. Blend into the red.

Layer 3
Use dark indigo pencil (or black) to give contrast and shadow. Fade out into the dark red.

Try it!

See water drop page

yellow

FINISHING TOUCHES!

Add bright red fineliner pen on top of the dark red pencil for a brighter look. Add subtle touches of blended yellow pencil near the white edges -on just a few petals- for warmth.
Add water drops... or
For pretty, frosted petals, add tiny dots of white posca pen (or gel pen) on and inside of the guidelines.
(try adding a few dots in silver glitter gel pen)

SOFT FLOWER HIGHLIGHTS

White ring.

Layer 1
Use a pale blue pencil to shade all over the petals, fading in towards a white ring.
Use yellow for the floral disc, leaving white in the middle.
Use grey to create a soft inner edge to the disc.
Make the white highlighted ring either thin or wide to suit your liking.

Disc

Layer 2
Dark blue pencil. Shade over the pale blue petals, but not quite as far into the white ring.
Add green pencil on the top edge of the disc & orange on the bottom.

Draw fine lines & dots on the petals in white Posca pen or gel pen.

Create a gem floral disc! (see gem pages)

Layer 3
Use black pencil to give shadow and depth to the petal edges, coming out from the centre.
Add a touch of red to the bottom area of the disc.

Layer 4
Your flower should have have graduated shading like this. (but full colour)
For extra glow, add a few soft sweeps of yellow pencil to the edges of the white ring area.

OUTLINED CLOUDS
(Do not use pens on this blank image other than those stated, or you risk bleeding through to the next page)

1 If you don't already have clouds on your page, draw some in light blue pencil.

2 Use blue pencils to shade your background. Dark blue at the top of the sky, blending down to pale blue at the bottom.

Then burnish (pressure shade in white pencil) to smooth out any grainy paper appearance.

3 In light grey pencil, shade the base of your clouds, and any areas of shadow.

4 Add a tickle of slightly darker grey. But not much in the body of the clouds or they will look too dull and rainy. NEXT burnish with white.

5 Add a touch of silver glitter gel pen to the grey. Draw it on, then smudge with your finger. Be quick! It dries fast.

6 Use white gel pen to draw over the cloud's guidelines. (May need to do this 2 or 3 times) This softens the edges & will draw viewer's attention to the shading, rather than to the black outline.

NEXT use black fineliner to draw distant birds.

OPTIONAL: Add a few dots and tiny stars in clusters or trails around the clouds in white gel pen for added interest.

MULTI-COLOURED GLOSSY MUSHROOM

Part 1

1 — leave white

Shade yellow pencil where indicated. Leave small white area in the centre.

2

Blend orange outside of the yellow. Add pink to the top edges, leaving a gap near the outline that is just a tickle of pale pink.

3

Fill with bright red where shown above. Blend into the orange and pink by going over the join in the orange and pink, once you have applied the red.

BLEND all your colours together to create a seamless transition.

4

Dark purple pencil.

5 — Dark red

Black over the purple in a 'C' shape, curling down under the mushroom

a bit of red here above the white highlighted lip

Dark red pencil. Where the purple meets bright red, and also at the very bottom lip to show it is darker where the light doesn't hit.

Example coloured from this guide!

6

Black - all along bottom of the lip.

Black pencil. To give more contrast/darken shadows.

THEN burnish (pressure shade) with a white pencil if you wish to smooth colours & remove white grainy paper surface.

MULTI-COLOURED GLOSSY MUSHROOM
Part 2

7 Light/mid grey pencil. Leave a white edge on the left side of the spot. (Fade out)

8 Add black for shadow and depth. Blend softly into the grey, but don't cover all the grey. REPEAT on all the spots.

9 Shade beige or tan pencil where shown above on the stalk.

BLEND all your colours togethers to create a seamless transition.

10 Dark grey pencil, but not too much pressure as the stalks are light in colour, not dark.

11 Black pencil. Lots of shadow cast on the stalk and the mushroom's underside, so this needs to be dark.

13 soften outer edges & centre of lip highlight with orange.

12 Add extra highlights here. main highlights. Finish by strengthening the main highlights in white gel pen. Add a cast shadow.

COLOURFUL SOAP BUBBLE OVER AN IMAGE

1 — Fade toward centre. Blue.

BEFORE colouring your illustration, draw a barely perceptive guideline circle where you would like to place a bubble. Shade blue pencil, from dark (hard pressure) on the outer, to light toward the centre. Leave the central zone uncoloured.

2 — Blue, Green.

Add green alongside the blue. Fade down to a tickle toward the central zone. Blend the blue into the green by tickling the lighter tone over the darker.

3 — pink or magenta, yellow, green, orange.

Colour the other segments. Blend as you go.

4 — Colour your line image using pencils. NOTE: Colour the area inside your bubble paler than outside of it, fade your picture into your colourful bubble border.

5 — Burnish all colours in the bubble by pressure shading with white coloured pencil. This will SMOOTH out your colours, help to blend & appear opaque.

6 — Use white gel pen to add highlights inside of the outer line, that flow with the circular shape. Allow to dry. Reapply for a brighter white.

7 — Use a fine nibbed (Tombow) eraser to lightly erase some background pencil inside the bubble zone - in the vicinity of the zones show by dotted lines.

7b — Pale the black colouring page guidelines inside the bubble with a light sweep of white gel pen.

Bubble border

8 — Use white gel pen to add starry glints. Draw glints... soften (blot or smudge with a Q-tip. Allow to dry. Then reapply gel pen to crispen the centre. If your bubble needs to be more defined or crisper, outline it in white gel pen.

9 — Add optional white dots in & around the bubble for extra sparkle.

FLOATING SOAP BUBBLES

1 Draw a broken circle in neon gel pens. (Use a coin or object as a template) Use a couple of colours.

or gelly roll pens

2 Area of few marks.

Draw more broken circle lines inside of the outer circle, in neon gel pens of different colours. Leave an area down the middle with hardly any marks.

3 Use white posca pen or gel pen for crisp chunky highlights, on opposing sides. Split the large highlight into a window reflection with black fineliner pen.

4 Add an option lens flare/glint, and dots in white gel pen or paint. Use white pastel for a softer base layer to the strokes of your glint if your background is made up of pen.

For smaller bubbles draw fewer inner lines or it will get fiddly.

Allow good drying time for the gel pens on this printed ink.

Try it! Finish this bubble

DAZZLING MERMAID SCALES

Use bright coloured pencils in the zones of colour shown. Ignore the scales... think of them as texture rather than individual spaces to colour. Use your light colours in the light zones, darker in the dark zones. Blend your colours together. Burnishing in white (stage 3) will help with blending.

1 — Purple, Yellow, Turquoise or green, mid blue, Pink, mid blue, White, Pink, Yellow, Purple, Turquoise or green, Purple

2 This shows where light & shade needs to be, to demonstrate form.

Use black pencil to enhance areas of shade, if needed.

Blend your colours, but don't 'muddy' them.

3 Pressure shade all over in white pencil.

4 Use white gel pen to draw a white line inside the black outline curve, of all the scales.

5 Next... use neon gel pens to add tiny dots in several neon colours all over the scales. Allow to dry...

6 FINISHING TOUCH
Sweep a clear, shimmery (very fine glitter) nail polish over some of your scales.

ANIMAL FUR *made easy!*

Meow

1. Place tracing paper over the entire animal shape.

2. Using a hard-nibbed, ball-point pen, draw marks on the tracing paper. Press hard to make grooves in the page below. Add closer marks for lighter areas, define different body areas (i.e tail) by varying your strokes. Tracing paper allows you to see your animal shape, so you know where to make the marks. (Place scrap paper under your page to protect the image beneath)

3. Remove tracing paper. Shade the animal shape in a medium brown coloured pencil, angle the tip. The impressed lines (grooves) will remain as white paper.

4. Shade yellow ochre in patches. Then... using a sharp dark brown pencil, add shadow to some individual white strands - this helps them look crisper & some to be laying on top of others.

5. Using sharpened pencil, add fur flicks over the top in dark browns, black or deep red.

6. Define the form by adding shadows in a dark pencil.

Shadow

Try it

Try different colours

TRANSLUCENT FAIRY WINGS

1. A bit darker around here.

Create your background in coloured pencils. Take the colour OVER the wings. Make some areas outside the wings a bit darker - for contrast.

2. Use white gel pen to draw over the wing guidelines. This may need two layers. Allow each to dry.

3. Scribble white gel pen on an edge of the wing, & smudge inwards with a finger. Be quick it dries quickly. Repeat around more edges of the wing. This creates an opaque effect.

4. Add white spots. Feather a few of the edges (for glow) by blotting, then applying more gel pen to the centre.

5. Add white star points to some of the spots.

6. Add little white and neon gel pen dots, on & around the wing tips. Then use silver glitter gel pen (or another colour of glitter pen) to add sparkle along a few sections of the white wing guidelines.

7. Optional: Add shadows. Add extra filagree to the wings.

Then colour your fairy!

Fairy image from book: Inky Theatrical Faces

Alternate: Colour your wings normally, then add white details on top

How to colour
3D SHAPES & OBJECTS

3D BOWS

Try it!

Leave protruding areas white.

Layer 1
Shade your bow in bright red pencil in the red areas indicated above.
The white areas should remain white. This is where the
light catches the bow and will give your finished bow a 3D appearance. The white areas
should be feathered, rather than a perfect ruler-edged line.
Keep your strokes soft and light where the red meets the white highlights, but use pressure
as you move away from the highlights to achieve a rich, saturated red.

Layer 2
Shading less area this time, use a deep red pencil
to shade the areas indicated in grey. This is building up depth.
Try to achieve a smooth blend between the two shades of red.

Layer 3
Give more depth by using a subtle amount of either dark indigo pencil, or black.
Blend lighter as you move from the edges into the main body of the bow.
You want a smooth transition leading into the deep red areas.
BURNISH all over in white pencil for a smoother look.

Finishing Touches!
Introduce bright red fineliner pen over the deep red pencil for extra boldness.
Introduce soft yellow pencil to the edges of the white highlights...
this will give a nice warmth to your bow!

LIGHT-CATCHING WINE GLASS

1 Shade the dark areas shown here in pale grey coloured pencil. Leave the white as white paper. Allow your background colour to show through (at the least, above the waterline) - glass is transparent!

- Crisp white (curved) highlights
- Crisp edge
- Soft edge

Shade softly to begin. You can always redo layers if necessary.

2 Using a mid grey, shade the layer shown here as medium grey. Blend into your pale grey layer.

Blend these mid grey areas across into the pale grey.

3 For a smoother finish… Burnish grey tones by pressure shading with white coloured pencil.

This highlight stops at the waterline, as it is on the back of the glass.

4 Use paint or white gel pen to extend this highlight down & over the waterline, as it is the front of the glass.

Waterline

6 Add some definition and contrast with crisp black pen where shown as 'black'.

Use similar shading techniques for glass tumblers.

7 To suggest coloured liquid: Shade over the tones below the waterline. Fade your liquid colour toward the white area. For red liquid, make the tones below the waterline darker.

BALLOONS

- pale pink
- Main white highlight

1

Colour your balloon in light pink pencil. Leave a white area as shown above. Shade the pink lightly in towards the white main highlight for a soft transition. Then blend the pink smoothly into the white by pressure shading over the top with white pencil.

- 2nd light zone
- Pink edge
- Pink edge
- Pink edge

2

Lilac pencil. (needs to be tonally darker than your pink) Shade where shown, blend well by shading over the join areas in the pink you used for the base.

Practice.... then try it in greens or blues! Try switching the pink to yellow.

3

Deep purple pencil. Blend well. Scumbling is useful for creating this balloon, to reduce pencil marks & little white paper grain flecks.

Each colour must blend slowly into the next or your balloon may look angular.

4

Darkest blue or Indigo.

TIP! Shade and blend over each new colour into the next by shading over the new layer with the previous pencil to help smooth out your colours.

5

Blend in some black pencil at the top and bottom. It gives more contrast & enhances the form, allowing the light areas to appear brighter.

6

Enhance the main white highlight if needed. Use white gel pen. Add a white dot on the second light zone, & the odd extra dot on the body of the balloon, and a feathered dot (blot with finger to create feathered (soft) dot)

scumbling method

SIMPLE BUT EYECATCHING, FIREY DRESS

1 Bright yellow pencil. Colour the majority of the dress, leaving some of the receding/ shadow areas untouched.

2 Blend bright red pencil. Press hard at the dips & creases (areas that fall back) for saturated, rich colour. Fade softly into the yellow protruding areas of fabric. Blend by burnishing in white pencil if more smoothing is needed.

3 Add dark red to darken creases and shadows.

4 Add yellow neon gel pen to the highlight areas shown here in blue. This gives a brighter and more interesting finish than using white.

Dots & glints. White and yellow neon gel pen - or silver glitter!

A GOLDEN CROWN

Remember to blend all your colours together.

One key to achieving gold: Harsh contrast of dark against yellows.

keep this area white

Colour these spheres in the same pencils, but use the method shown on the 'Sphere' page.

Crown lips

1) Yellow pencil or dark naples ochre

2) Raw umber (tan)

shade from dark brown, to tan & yellow on the crown lips. Leave a length of white in the very middle

3) Dark brown

Add shadows under the spheres, jewels and length of the lip.

FINELINER

4) Black fineliner pen
Blend by going over with dark brown again

5) Touches of green and red can improve the golden tone if your colours aren't quite right.

Add a soft touch of earthy green pencil in a few places blending with the yellow and raw umber.

Gold is not easy to achieve on the first try... keep practicing.

Try some venetian red blending with the edges of the raw umber

(like a deep salmon)

GLOWING CANDLES

1

Yellow (fade down into the white)

Yellow outer zone

Leave the centre white

Yellow outer glow zone (fade out softly into your background)

2

Orange (outside of the candle guidelines)

Mid blue (fade up into the white central zone)

3

Orange (Inside the flame guideline) Leave a white gap between your guideline & orange. (see pic below) Fade your orange softly into the white

Add a light touch of red on the orange if you'd like a bolder look.

4

Cadmium orange (a yellow-orange) Blend this between the orange around the guideline & your yellow outer glow.

EXTRA sparkle? Add silver glitter gel pen over the blue.

White gap between guideline & orange.

Top area of wax would be lighter in colour due to the heat.

It is easier to practice on large candles first.

Try it!

red *white*

GLOWING LANTERNS

Shade the zones

1
- Very faint yellow pencil
- Bright yellow
- Leave central zone white.

2
- Cadmium orange (a yellow-orange)
- BLEND colours together as you go.
- Orange

3
- Add a little black in the corner points on top of the brown.
- Dark brown Aswell as the 4 corners, shade brown under the top of the lantern -as shadow.
- Dark brown

4
- Yellow pencil or pastel. (Outer glow) (fade or smudge yellow out into your background.
- Use light, feathering circles to build & blend your colour.

5
TO FINISH...
Pressure shade over the whole area (except central white zone) with yellow pencil.

Try it

CHROME IT UP!
with black, white and grey

White highlights

Pale edge alongside the crisp black

white fading across to grey coloured pencil.

white

Begin by shading the black sections in pen. Crisp edges. Using pen for the black gives a more solid coverage.

Add a cast shadow.

Add the grey tones. Fade the strong black at the base to soften it up into the ball - as this is the cast shadow reflecting back on to the ball, so it needs softening.

reflection from handle

reflection on the body from the spout

white highlight

Gradients bulge, flowing with the shape.

White highlight spout reflection

Dark reflection from the surface shadow beneath Chrome reflects like mirror.

grey shading curve guideline

Fade down from the strong black centre

Stripes here... are straight up and down due to the shape.

Use a black pencil to deepen the grey in dark areas, if you wish.

Blend over greys with white pencil for a smoother finish.

Stripes taper inwards due to the shape.

shadow under the lip.

white

A chrome letterbox plate

Curve at the edges of the plant pot, leaving a space at the lips/top & bottom of each section.

soft grey fading into the white

dark grey/black pencil softens the black pen.

CHROME IT UP!

Polished metal requires strong shadow and light, along with soft grey. Chrome acts like a mirror... but without getting overly complicated, here are some basics for creating a 'chrome effect' on objects on your coloring pages.

Shading should be fluid, and directional with the form. Some black areas need a crisp strong edge, whereas others need softening.

Materials used:
Black pen,
dark grey pencil,
black pencil.
White craft paint or gel pen can be used to brighten white highlights.

white
grey faded edges

crisp
soft

Replicate these 4 chrome hearts. The simpler ones are best used on small hearts. The more detailed are best on larger hearts where there is a greater area to fill.

white
white highlight
grey fading across to the white

A bangle

Crisp white highlights inside the solid black.

Try very subtle blue over the grey!

darker grey on the edges

Chrome acts like a mirror. The colour & shape of nearby objects would be reflected in the chrome.

Red ball reflection
Red ball

GLASS-LOOK TEARDROPS
multiple uses!

1 Pink coloured pencil.

2 Add a darker pink or purple tone. Blend into the first colour.

3 A darker and richer shade.

4 Blend in some dark indigo. Press hard to get saturated colour, and blend.

Blend colours together as you go.

5 Black on edge. Add some black for extra depth and contrast.

6 extend white highlight up in 2 fine lines, flowing with the shape.

Add yellow pencil here, blend out into the surrounding light pink. The yellow gives it a more glass-like lift.

7 Blurr this highlight's outer edge. Blot the white with finger to smudge, then reapply.

Use a whiteout pen, or white gel pen to add highlights.

Try different colours!

Add shadows.

a great idea for fish & mermaid scales...

...and bird feathers.

How to colour
DRAMATIC LIGHT CATCHING GEMS

PURPLE & YELLOW GLASS GEMSTONE

1 Shade all over (except the white area shown) using lilac pencil. Shade lighter in towards the white smile-shaped zone for a smooth transition.

2 Lilac border. Lilac border. Add dark purple pencil. Blend into the lilac by shading over the top in the lilac pencil so that there are no crisp edges of purple, just a smooth flow from one colour to the next.

3 Add magenta! Blend well. This compliments the purple, and will give a richer, warmer look to your gem.

4 Leave a smile of white. Blend yellow in and over the edges where the lilac meets the white smile zone - still leave some white in a 'smile shape' in the centre of the yellow. Blend by shading over the yellow in white pencil.

5 Blend black pencil around the left edge, and right inner curve of dark purple. Blend the black by shading over it with your dark purple.

Try it!

6 *Use a couple of layers of white gel pen for the highlights.* Use a very sharp black pencil to add cracks - go lighter in the white & yellow zone. Then add crisp, white highlights to make your gem shine!

OVAL GLASS GEMSTONE

1 Shade all over (except the white area shown) using light blue pencil. Shade lighter in towards the white zone for a smooth transition.

Light blue border.

2 Add mid blue pencil, and blend. Leave a border of pale blue around your gem.

Try it with greens or reds instead of blue.

3 Now your darkest blue. Then pressure shade over all your colours in either white pencil or pale blue to smooth out your colours, and rid of any white paper grain flecks.

Leave some white

4 Add yellow to the edges where the pale blue meets the white zone - still leave some white in the centre. Blend the yellow in to your gem by pressure shading with white pencil.

5 Blend black pencil around the edges, still leaving that border of light blue. Blend the black by shading over it with your darkest blue.

6 Use a very sharp black pencil to add cracks - go lighter in the white & yellow zone. Then add crisp, white highlights to make your gem shine!

GLOSSY RED HEART

1 Leave a white gap

Pale flesh pencil. When you burnish in white later, the white gap will become very pale flesh.

2 Add pink pencil in the area shown. Blend into the flesh. Then shade over the top in the flesh colour for a seamless transition.

Try it

3 Add bright red pencil. Blend, and shade over the top in the previous pink.

Top curves

4 Deep red pencil. Blend, and shade over the top in the bright red.
NEXT:
Burnish - pressure shade all over in white pencil. This will blend all your colours even more and help rid of any white grainy flecks of the paper.

5 Bottom tip

Add black inside of your outline. If your heart is small and fiddly, just add black at the bottom tip & top curves. Softly fade into the deep red. This helps to give more of a 3D apearance. Go over the join in deep red pencil to help blend the two together.

6 Add white highlights in gel pen or craft paint. Fade the right highlight down so that the top is bright white and the bottom of the highlight is fading away. Use a Q tip or finger to sweep the white down in a curve.

OPTIONAL: speckles in black pencil, white & gold gel pen. Or little cracks in sharpened black pencil.

7 3mm eraser

Use a small-nibbed art eraser to remove a little of the deep red here, as an extension of the white highlight.

PLAIN

TEXTURED

8 Add your choice of shadow.

GLINTING CRYSTALS

Try other colour schemes!

Try light turquoise.

1 Colour in light and medium blues.

Palest facet — Place a little blue on left of top facet, then blend it across with white pencil.

Try dark blue fading up to light purple, or pink

Top / **Back** / keep the right half white

2 Shade from dark to light. Keep the top facet light, the back facet the darkest.

Using pens? Chameleon pens shades light to dark of a colour.

Lightsource

3 Show light reflecting inside... Use pencils that are darker than each facet, to add little patches on the facets. Then use a fine nibbed eraser (Tombow) to erase some colour to create light patches.

It's ok if some bits of guidelines show through.

Top half

4 Use white gel pen for thin lines on top of some guidelines, on the top half of your crystal. It doesn't need to be precise.

For higher impact... Vary your colours within the facets, & try a sweep of clear, shimmer (very fine glitter) nail polish on top! You may need to reapply the white gel pen on top of the polish.

White triangle

Triangle

5 Add strong white triangles on a few facet edges using white gel pen.

6 Add little white dots to the top half.

Add a white glint.

Alternative: Scribble texture.

7 Add thin directional, suggestive white lines on the top half of your facets.

Mix it up! Vary colours on each facet.

Try it!

CREATE A RED RUBY

Try it

Red inside top facet

1 Shade your gem all over in light pink pencil.

2 Use a bright red pencil to colour the areas shown, blend softly into the pink for a smooth transition. Don't forget a ring of red inside the guideline of the top facet - it will help give the facet a raised appearance.

3 Smooth the pink and red even more by pressure shading over the top with white pencil.

4 Add dark red pencil. Blend into the bright red. Going over the dark red in bright red pencil will help you blend.

5 Add black pencil. Build this up gently. You want to darken some areas of the dark red, rather than achieve a harsh black.

3mm eraser

Use a fine-nibbed art eraser (tombow 3mm) to erase some pink from the areas shown in blue. This creates a lighter pink in defined patches.

White gel pen

7 Use white gel pen or white gelly roll pen to add highlights as shown. Do 2 or 3 layers to create bright white. Allow each layer to dry before reapplying. Optional: add white dots or glints on and around your ruby.

TRANSFORM BLANK SHAPES INTO GEMSTONES

using pens! You need 3 or 4 shades of a colour.

Practice these gems in a large size to begin.

Some pens will bleed through, so try this gem on the practice page, not on here.

1 Take your blank tear shape

2 Draw very faint guide lines in an ordinary (erasable) pencil.

3 Use the darkest pen of your chosen colour scheme (or black) Fill these zones, (mainly around the outer edge)

4 Fill in your next shade, a little lighter than your darkest previous pen. Your dark tones are mainly around the outer edges.

5 Keep this triangle white. It's a highlight. — palest — Lighter than step 4. Now fill in the next 2 lighter tones.

6 Light area — Dark area — Fade across. If you don't have pens that will fade down in colour, or pens of graduating tones, then colour your dark area of the front facet in pen, and fade your colour out and across in a coloured pencil similar to that of your pen.

7 For a finishing touch... add a glinting star highlight in white pastel, gel pen or paint.

Try different shading techniques.

Leave white gaps between sections. or scribble your colour.

GLASSY GEM BUGS

Press hard for rich, saturated colours.

1 Fill your shape in yellow pencil up to half way, at a diagonal. Shade colours over any details.

2 Add orange pencil in the central zone, leaving two white curves as shown. Blend the orange into the yellow lightly, then go over the orange in yellow to blend harder.

Leave white

3 Red pencil. Blend down into the orange.

Build up colours by scumbling.

Try it!

4 Add deep red pencil at the top left, a small amount under the head, & down the right edge of the body.

Right edge

5 Shade some black pencil over the deep red for greater contrast. Fill the spots in a mixture of black pencil & pen, so that some areas (using pencil) can be paler to show the catching of light.

Pale red

Highlight

6 Shade the two white areas in a pale red or pink, so that it is still almost white. Then use white gel pen for bold, crisp highlights, flowing with the curve of the body (left side), & applied over the top of any details. Add soft shadow beneath.

GLASSY GEM BUGS

purple beetle

1 Shade the white zones a pale flesh (or use the same pink but apply lightly.)

1 Shade a medium pink pencil where shown.

2 Add magenta & blend into the pink.

- A bit less saturated at the top here
- More saturated here

3 Blue violet (dark) Blend into the magenta. Then pressure shade all over with white pencil for a smoother finish, start with light areas first.

(so as not to muddy the flesh zones too much)

4 Use a black pencil to shade along the inside outline of your shape for definition & depth.

Crisp white highlight (flowing with the shape) over the pale pink.

add a solid circle of white. Dab to feather the edges with fingertips, then reapply white to the centre for a crisp centre.

Use white gel pen to add bold highlights.

5 Don't forget to add a shadow to help your glossy bug leap off the page!

Try it!

GLASSY ORANGE FISH

For bright, bold fish, press hard with your colours.

1 Fill your shape in yellow pencil. Shade colours over any scales or details.

Try it!

2 Blend down

Add orange pencil in the 3 zones shown above. Blend into the yellow so that the zones of orange blend down to meet each other.

3 Red pencil. Blend red in the areas shown.

4 Deep red

Leave this bottom edge yellow

Add deep red pencil on the belly, and a thin amount along the top & bottom right edges. Blend. Burnish. For more contrast, add black pencil over the deep red.

Try different colour ranges... like green and blue fish.

Little highlight at the top.

5 Use white gel pen for a bold, crisp highlight, flowing with the shape, & applied over the top of any scale details. Add shadow beneath the fish.

A STUNNING SILVERY PEARL

Colour the layers by shading the areas shown in grey. Starting with light to dark tones.

Practice large before trying on small circles.

Here are the different tones for guidance. Don't forget to BLEND the layers together.

Main hightlight

START with your palest grey pencil (just tickle the paper

Light grey pencil Blend smoothly.

Medium grey (or dark grey with less pressure)

Try it

Darkest grey pencil

When you have finished... smudge a little grey here, so that it is slightly less white than your main highlight.

Add a cast shadow to make your pearl look even more realistic.

The better you BLEND your pencils together, the more polished your pearl will appear.

Black pencil

Try introducing soft pink or blue to the grey tones, to create a tinted pearl.

POLISHED AMBER GEMS

Layer 1
Use a yellow pencil to shade the area shown.
Areas shown in blue are to remain white.
They are blue for the purposes of this guide,
so that they are clear to view. We will emphasise
some of the highlights later.

Layer 2
Orange pencil. (shade areas shown in grey)
Blend your orange smoothly into the yellow.

Try it →

Layer 3
Beige or medium brown pencil.
Shade hard enough so you can see the brown
on the orange. Blend really well into the
orange for a smooth transition.
Use a darker shade of brown
if necessary.

Layer 4
Shade in black pencil.
Blend well, then shade a soft line inside of the outline.
Redo previous layers if the colours aren't saturated enough.

Layer 5
Black fineliner pen.
Shade areas shown. Then redo the black pencil for a
smooth transition between the two blacks.

Layer 6
White craft paint or gel pen for highlights.
Add extra dots for sparkle if needed. Be sure to
have some sparkle over the black pen for high contrast.
Add optional little cracks with a sharp pencil.

CREATE A SHOWSTOPPING BLACK DIAMOND

1 Draw an inner border in your pear/tear shape

- Black pen
- Dark grey
- Mid grey
- Lighter grey
- White

2 Divide into 6 points, & connect by drawing triangles.

3 Repeat on the opposite side.

If using pencil, burnish your sections for a smooth finish.

4 Draw these additional triangles

5 Half these

Add a small dark grey triangle here.

6 Dark, Mid, Dark, Mid, Light

Fade bottom inner border edge up into the diamond.

NOTE: Practice with pencils on this page. Use pens on the practice gem sheet - which is single-sided.

Try it!

7 For a clear diamond border... Shade light grey in tiny fragments, followed by darker grey & some specks of black inside of that. Be sure to leave lots of white areas.

Primsacolor Premier pencils are great for this gem!

OVAL GALACTIC GEM (SIDE VIEW)

1 Use pink pencil to shade all over except the two white areas.

2 Add dark blue. Remember to add a thin line of blue around the base.

3 BLENDING 1 Use a white pencil. Blend the pink and white zones first.

Top left

4 BLENDING 2
Still using the white, blend the pink and blue zones. Blend the top area up and across to the left, so that the top left is less muddied by the blue and still remains a little pinkish.
Blend the blue line around the base, but still keep it as a thin line. Then blend the main blue. Pressure shading in white smoothes out the colour & removes little grainy flecks of the paper for a smoother finish.
Blending your pink and blue willl create a third colour, lilac.

Lighten the left of this curve (in the zone shown)

only slightly lighten this

5 Use a fine-nibbed art eraser in a scumbling motion, (Tombow 2-3mm) to lighten the pink areas shown.

white curved line highlight

6 Add bold white highlights in your chosen medium. White posca pen, or gel pen works well.

7 For a galaxy effect. Add speckles using pink & blue neon gel pen, a few tiny white gel pen dots, and black fineliner pen. Add shadow in dark grey or black pencil.

Not soft core pencils? Fade your blue into pink, shade over join areas with pink. Then use the white.

Try it here

PRACTICE GEMS

How to create
BACKGROUNDS & EMBELLISH

SNOWFALL BACKGROUND

Colour your background areas in blue pen.

Spread correction fluid along the bottom. (Less soggy on paper than paint)

Blend over the blue pen using fingertips, tissue or sponge.

White soft pastel smudged in circles.
(soft pastel isn't as effective on a pencil background)

Darker blue soft pastel smudged in circles.

White liquid chalk marker (3mm nib is good) Dab dots. Lighten some by dabbing a little off with fingers.

White gel pen. Add tiny little crosses.

White gel pen. Add tiny little dots.

White gel pen. Draw snowflakes: some lighter by dabbing off, some brighter with a 2nd ink layer.
(Try silver glitter gel pen too.)

STAINED GLASS WINDOW EFFECT

1 Colour your picture (in pens is best for this technque)

Add an optional glint & diagonal lines in white gel pen at the end.

Works best on images that are coloured in pens

2 Section your picture with thick dark grey lines. (preferably pen because it is bolder) Simple squares or more elaborate.

Image from book: Inky Whimsy

This is vignett

No vignett / Vignett

3 Create a vignett effect by shading the inside corners dark using black or dark grey pencil. Fade softly into the image.

4 Shade over image lightly with a blunt, angled tip. Use different colours for different sections. Build up your colour slowly. Light/mid tone colours work best.

Use different colours for different windows.

5 Add shadows to the grid lines on all the squares. Use black pen under the horizontal lines, and also to the right side of the vertical lines. This gives your window grid a raised appearance

red / yellow / blue / green

6 Add thin highlight lines on frame in white gel pen or gold metallic. with a fine nibbed gel pen. Burnish squares with white pencil for smoother finish.

GIVE FLAT COLOURING A BOOST!

Flat colour — Nothing stands out, it lacks depth.

Even by adding just basic white highlights alone...
(in gel pen, pastel or craft paint) can give your image a great lift!

Take it to a whole new level... by adding roughly sketched light & dark tones, the illustration now has depth, a focal point, & character.

Graded highlights & lowlights (dark)

Highlights, lowlights & drop shadow

The illustration commands attention. Not only does it have depth, focal points and character, but it appears to be raised off the page - giving it a 3D appearance.

Reflected light

Background, dots, shadows falling on the object behind, & starry glints.

RED SUNSET OVER BLUE WATER — Part 1

1 Leaving a space at the top for your sun and sky... Fill in your area with oil pastel sticks. Use blues, turqoise, yellows... (Darkest blues at the bottom) make horizontal marks, to build up and create water.
Oil pastel can appear 'bitty' & lumpy - this is okay and adds to the effect of light catching on water.

Oil Pastel

2 Use coloured pencil to neaten the edges next to details on your page.

3 (Adult supervision) Use the sharp point of a scalpel blade to gently scrape horizontal lines down the centre of your page. This removes thin lines of oil pastel, revealing the white paper underneath, & giving the impression of sunlight reflecting on ripples.

Do not scratch too hard or you will scratch through the paper.

4 Tear a circle of blank paper for a sun template. (Tear so that it is feather-edged)

5 Position the circle on your page at the top of the water, in the centre.

Soft Pastel

6 Using SOFT PASTELS this time, hold the circle in place with one finger, and using the fingertip of your other hand, rub grains of yellow soft pastel over the edge of the circle, covering all the sky, push into the tooth of the paper. (DO NOT APPLY the pastel directly to your page as this makes heavy marks. Rub colour on scrap paper & lift pigment with a dry fingertip)

The paper circle will remain as white.

RED SUNSET OVER BLUE WATER Part 2

7 Make your yellow pastel around the sun BOLDER by going over it in yellow coloured pencil. This makes the sun appear whiter, & therefore brighter.

8 Smudge orange pastel (lift the grains off scrap paper with dry fingertips) into the sky, leaving areas of yellow visible around the white sun.

9 Remove the white paper sun. Tear a long feathered edge along a piece of blank paper.

10 Position the feathered edge across your sky, ending a little before the sun.

11 Scribble soft RED pastel onto scrap paper. Lift the grains with dry fingertip. Smudge pigment up over the feathered edge, onto your sky, getting lighter in colour near the sun. Push the pigment into the grain of the paper.

Lift the grains off scrap paper with a dry fingertip.

Lighter

12 Aim for darker red on the outer edges (more pigment, go over it a few times)

Darker

13 Move the torn edge up a little higher. Repeat. Then repeat on the other side of the sun. This will give you a nice streaky, dramatic sunset. Go darker if you wish!

14 Remove excess pastel dust with a light tissue. (Don't blow) Sweep it very gently over the sky. This will also soften your red feathered lines.

15 FINISH - Draw birds across the sun in black fineliner pen. This provides a focal point, adds contrast & drama!

SOFT WATER BACKGROUND EFFECTS

1 Cut a wave along the longest side of blank paper (or clear acetate which helps you view the areas of the page you wish to colour.)

2 Rub soft pastel on to scrap paper.

3 Lift up the grains of colour with a dry fingertip.

4 Choose your colouring page.

5 Place the wavey edge over your artwork. Ensure your hands are bone dry!

Dust off excess grains with tissue. (Don't blow)

6 Rub and smudge the pastel grain, up and off the wavey edge, on to your chosen sections of your page.

7 Move the paper down and sideways to a different position. Rub and smudge again.

8 Repeat, moving down the page, try varied shades of blues and turquoise.
(Do not wet the paper as this causes blotches)

Once complete add air bubbles, white paint spatter or stars!

Experiment! Smaller waves, more layers & colours.

9 For rippled water (rather than waves) go back over the whole area, vary the angle, overlap some of the waves.

MORE PASTEL 'PAPER MASKING' BACKGROUND IDEAS!

Cut cloud shapes. Move & angle the cloud.

Alternate colours!

Fanned - lines across. turn the paper from central point

Try mountain peaks (see bottom of page) below the clouds!

Gingham - lines across then down

Cut smaller shapes to fill small areas.

overlapping (& flipping) layers of soft waves in brown/orange pastels creates rippled SAND.

smudge then overlap.

Use a paper doiley or cut a snowflake out of folded paper.

Smudge pastel grains over the edges of dried leaves & other flat objects.

Tear mountain peak shapes (don't cut) Smudge pastel & overlap. Use lightest colour at the top so the mountains fade into the distance.

Cut circles out of paper. Place a few on your page. Smudge pastel. Place more circles over the first. Then repeat. Once finished, remove all the paper circles. Use different sized circles & a darker pastel for each layer.

SHIMMERING, RIPPLING OCEAN WATER
Using the 'impressing' technique to create guidelines

Place CARD underneath!

Sweeping lines of PVA glue (at the end) add another dimension of interest.

1 Place tracing paper (or greaseproof cooking) over your design. Use a ball-point pen to draw swishy lines on the tracing paper in the areas you wish to cover - hard enough to create impressed lines in your colouring page. Looser but flatter at the top to show water fading into the distance. Work around items like fish, showing some or all. To show fish beneath the surface, give them a muted/lighter colour with some blue. Have smoother lines for calmer water.

2 Remove the tracing paper. Shade a base layer over the impressed area with light blue pencil. Angle your pencil tip so that you don't make sharp marks, and that it glides over the impressed lines - which will remain as white.

Shade water lighter in the distance.

3 Using a yellow pencil, shade some areas (not all) to introduce a subtle turquoise quality.

4 inside of the white impressed sections, shade dark blue (navy) coloured pencil. Press hard for saturated colour in the centre, fading out lighter toward the white impressed guidelines.

Dark navy in central sectors

5 Use white craft paint on a fine brush, to sweep across the impressed lines. Smudge (almost wiping the paint off) with your fingertip - this gives a soft white trail along your impressed line.

6 Using the same fine brush, drag neat white craft paint along some of the lines. Aim for some areas looking blobbed and thick, others fine and broken or sparse. Remove mistakes with a sweep of your fingertip.

7 Make your water SPARKLE! Finish with some glistening white dots, bubbles or stars! (Use paint or white gel pen or even silver glitter gel pen)

WAX RESIST, STARRY BACKGROUNDS

Only certain (weighty) papers will hold watery paint without bulging or wrinkling when dry. Test your papers beforehand!

1 Use the edge of an unlit, white candle to draw designs on your colouring page around your objects..
In this example I have drawn very basic squiggly lines around the feather, but you can EXPERIMENT WITH MORE INTRICATE PATTERNS!

2 Using a soft paintbrush, brush watercolour paint over the surface around your colouring page objects. Be sure to use enough water... The wax repels watery paint, leaving your pattern on show!

Note: Watery paint will wrinkle the paper in this book.

3 Drop some (optional) shimmery ink on the base for a little glow. Then add splashes of craft paint by spattering off a brush. Protect areas you don't wish to splash paint on with pieces of appropiately shaped paper.

4 Using the end of an orangestick, (or a ballpoint pen which has dried up (contains no ink)) drag the paint out from the centre of a few paint blobs to create little stars.

wax ideas: circles, lace, waves. Bark-rubbing!

5 For extra contrast, create more stars in different coloured paint and shades.

BRIGHT GALACTIC STAR

This technique works best on a pen background, using white soft pastel & white craft paint for the star. However... if your background is made of coloured pencils or soft pastels, then opt for white oil pastel, white liquid chalk marker (3mm nib or less) or white craft paint for the strokes. (Test what works best on your chosen medium & paper)

(Place shaped pieces of paper over elements that need protecting from spatter. Don't use too much paint or water incase your paper wrinkles)

1 Create your background, either multi-coloured or plain. Add fine paint spatter by flicking coloured paints off the end of a toothbrush using your thumb.

2 Create a fuzzy-edged circle in your white medium. Blot or smudge to create a fuzzy edge. If using liquid chalk... dot & dab, allow to dry then repeat. Don't drag the chalk. (The wetness all on one spot may tear the paper)

Create outward strokes in your white medium, starting from the central point. If the ends needs fading out, smudge with a cotton Q-tip. (be quick if using liquid chalk, it dries fast!) Crispen the inside of the strokes with white craft paint on a fine brush or white gel pen.

3

4 Brighten the centre with a dot of white paint.

5 Add an optional thin ring for extra glow.

Try distant glowing planets with little surrounding moons.

Add more stars. For tiny stars try white gel pen.

Stars can be used to highlight objects, or as magical little details to any background.

FAIRY DUST TRAILS

Test your mediums work together on scrap paper.

1

FIRST: Colour your fairy & background in pen or pencil.
NEXT: Draw soft trails/rings in white liquid chalk marker. It can be a little translucent if you draw quickly - so perfect for this.
Blot or soften with a Q tip if needed.
Aim for light, feathered sweeps.
Allow to dry.

3mm Liquid chalk marker

2

Using white paint on a fine brush, paint a crisp thin line along the middle of each trail. (You can also use white gel pen applied lightly so as not to remove the chalk)

(For extra sparkle add a touch of glitter/glitter gel pen!)

3

Add tiny white dots and stars around the trails.

(Try white gel pen or paint for tiny stars.)

WOOD GRAIN
Using the 'impressing' technique.

Use this technique to create other exciting backgrounds!

Use this technique in the scene at the end of the book.

Place tracing paper over your colouring page. Using a ball-point pen, draw wood grain on to the tracing paper in the areas you wish to cover. Apply heavy pressure to create grooves (impressed lines) in your colouring page beneath.

(Place cardstock under the colouring page to protect the illustration beneath)

Remove the tracing paper. Shade a base layer over the impressed area with light tan brown pencil. Angle your pencil tip so that you don't make sharp marks, & so that it glides over the impressed lines - which will remain as white.

Using a dark brown pencil, shade inside of the white impressed lines, fading and blending into the light brown. Dark brown against the white impressed lines make the grain stand out more.

Add random areas of yellow ochre, orange or other browns to achieve the colour of wood you desire.

A few touches of black against the white grain gives more depth and contrast.

For a smoother finish, burnish the whole area by pressure shading over the top in white pencil at the very end. (as pressure shading would flatten the impressed lines)

white pencil

A CONTEMPORARY TWIST

Add fun shiny paint drips to your artwork in the colours of your picture.

1 Draw a faint pencil outline.

2 Fill with red pen, all except the crisp white highlights.

3 Use a deep red pencil to add darker tones in the areas shown. Be sure to blend into the bright red.

4 Add black pencil. Keep the outer edge crisp & dark, blend the inner into the deep red.
Crisp black edge

5 Blend your pencils by reducing pressure.

Crisp white highlights give a shiny, wet appearance. If you forget the highlights, add them at the end in white gel pen.

vary the shape & size of your drips.

To add drips to areas already coloured: Use white craft paint for a drip shape. Allow to dry. Then colour as above.

Craft Paint

Try it!

RUBBINGS & DOTS

Place your page over a textured surface. Holding a coloured pencil at an angle, gently rub (colour) side to side on your page.

Copic Ciao markers allow you to create small to large dots with the super brush nib... by pressing hard or lightly.

Make large dots near your design, getting smaller as you move away. Add a second colour.

Rubbing ideas: Pavement bark wicker/rattan. Plaques. Dried leaves.

Use white gel pen or craft paint to add bright white dots on top.

(Try rubbing over a leaf)

Ensure your textured surface is dry before rubbing over it.

SHADOWS

Visual effects giving the appearance that
your object is raised above other objects or surfaces behind it.

Use pencil to create a shadow. *Try it!*

You can use black and dark grey pencil for most shadows.

No shadow.
The image looks flat, lacks depth and has no relationship with it's surroundings.

Cast shadow.
Object is standing upright on the surface.
The shadow is elongated/fades away.
The shadow can angle to one side, depending on where the lightsource is.

Don't forget shadows where objects overlap each other.

Soften the shadow as it fades away from the object.

Lightsource

Drop shadow.
The shadow is right against the image, showing that the image is flat against the surface.

Heavy, distant drop shadow.
The image and shadow are staggered.
The image is hovering above the background.

PRETTY MOON & STARS BACKGROUND

1

Fill the background around your image in solid black marker pen, or shades of your choice.

2

Faintly draw a moon crescent outline, then fill in with neat (undiluted) white acrylic craft paint, & a fine brush,

OPTIONAL: Add smudged soft pastel over the marker for a more artistic look. See pastel background page for ideas!

3

Left edge

Once dry, use a black pencil to shade over the left edge. Press hard near the edge for a seamless join, then softer into the moon itself. The slightly rough surface of the paint will create a surface texture.

4

Use gel pen or white paint to add little spots. Feather the edges of a few for a glowing effect, by smudging or blotting. Brighten the middle with more gel pen or paint. Use gel pen to add little star points/lines.

5

Using silver glitter gel pen, draw lines going from each star up to the top of the page. Then, use white gel pen to add little dots along each line of glitter.
Add more line/ dotted lines & dots in neon & metallic gel pens.

6

Use bright neon gel pens to create smudged shooting stars in yellow, pinks, blues... (See the fireworks tutorial page for details.)
Add tiny dots, white & neon gel pen, around the moon's edge

Create this effect across the whole top width of your colouring page.

MARKER PEN BACKGROUND

Shade your background in marker pens however you desire... solid, mixed colours, or blots and dots... (Mid - dark colours work best for this technique)

Squirt hand sanitiser gel (the kind that kills bacteria that you'd carry in your purse) onto a plate.

Screw some tin foil (aluminium foil) into a loose ball, so that is has lots of dips and creases.

Dab the foil onto the hand sanitiser, then lightly dab on to your marker pen background. Do this all over your background, but leave gaps, and don't over saturate or your paper will wrinkle. If it wrinkles, this will lessen once dry.
Be careful not to transfer your marker pen to your colour page images when dabbing.

Allow to fully dry. The hand sanitiser pushes away the ink as it dries, leaving a marbled-type effect. Once evaporated and fully dry... colour your page.

Experiment with other objects and textures.

Try it with cookie cutters of various shapes, a brillo pad or wire scrubber...
Objects with deep texture, and good gaps between the textured peaks work best.

NEON FIREWORKS! *gel pens*

smudges: short near centre, longer on outskirts.

Shade a black marker pen background. (place blotting paper under your page) Draw lines in yellow and white pencil.

Draw a tear shape in white gel pen near the inner of the area. (Brightest colours on the inner areas)

Smudge the ink toward the centre with your fingertip. Work FAST, the ink dries in seconds!

Repeat this in a circle. Some blobs thinner than others. Smudging makes the ink 'trail' off.

Repeat the process with yellow neon gel pen outside of the white.

Next... pink neon gel pen.

... then purple neon. (your least brightest colours on the outer edges)

Add more firework smudges if needed... Then little dots (sparks) with the same pens.

Actual firework drawn using this technique

Go over all of your colours again (in the centre of each streak) with the same pens, to brighten the centre of each streak, as the black pen and paper will absorb some of the bright gel colours.

Medium _____ Date _____

Practice BLENDING coloured pencils together in the wheel, shade lighter in gradient toward the centre.
Then... have fun!
Experiment over the top with the suggestions below.

Help & tips are within the book!

Try blending your colours into the next in the outside border.

EXPERIMENT!

Opposing colours are COMPLIMENTARY & therefore look good when used together.

add a shadow under the wheel

YELLOW Primary
Yellow-orange Tertiary
Yellow-green Tertiary
Warm colours
Orange Secondary
Green Secondary
Red-orange Tertiary
Blue-green Tertiary
Primary RED
Primary BLUE
Cool colours
Blue-purple Tertiary
Secondary **Purple**
Tertiary Red-purple

Wheel segment suggestions:
- Blend red at the top. Add crisp white highlights.
- Remove circles of pencil with Blu-tac or kneadable eraser.
- Add streaks of PVA glue for a water shine.
- Add tiny white stars in gel pen or paint.
- Rub this section over a stone path or concrete for texture.
- Add oil pastel, & scrape shapes off using a scalpel
- Add streaks of white paint, & smudge across to fade for a water effect.
- Give depth by shading & blending black pencil on the edges
- Splatter this in paint flicked from a toothbrush.
- Cover other segments.
- Add bubbles
- Add dots of different colours of neon gel pen
- Add a star glint

Cooling
relaxing
refreshing
tranquil, passive
distant, safe

Stimulating
warming
cosy
happy
personal
energetic
passionate

WRECK THIS PAGE... HAVE FUN !!

colored by; _____

Test how colours work with and against each other!
Test complimentary colours, primary, random, cold, warm, tints & tones...
Record your medium and colours used to refer back to.
Try combining mediums to see how they work for you.

SIGNATURE CARDS

Color, cut out, back with cardstock. Place next to your art & take a photo.

Coloured by	Coloured by	Coloured by
Coloured by	Coloured by	Coloured by

Colored by	Colored by	Colored by
Colored by	Colored by	Colored by

Colour Chart (Pencils)

Colour Chart (Pencils)

Colour Chart (Pencils)

Colour Chart (Pencils)

Colour Chart _____

Colour Chart _____

Colour Chart

Single-sided charts (for pens/markers that bleed through)

Colour Chart _____

Colour Chart _____

Colour Chart _____

Made in the USA
Coppell, TX
25 June 2021